50 THINGS
BOOK S ...
REVIEWS FROM READERS

I recently downloaded a couple of books from this series to read over the weekend thinking I would read just one or two. However, I so loved the books that I read all the six books I had downloaded in one go and ended up downloading a few more today. Written by different authors, the books offer practical advice on how you can perform or achieve certain goals in life, which in this case is how to have a better life.

The information is simple to digest and learn from, and is incredibly useful. There are also resources listed at the end of the book that you can use to get more information.

50 Things To Know To Have A Better Life: Self-Improvement Made Easy!

Author Dannii Cohen

This book is very helpful and provides simple tips on how to improve your everyday life. I found it to be useful in improving my overall attitude.

50 Things to Know For Your Mindfulness & Meditation Journey
Author Nina Edmondso

Quick read with 50 short and easy tips for what to think about before starting to homeschool.

50 Things to Know About Getting Started with Homeschool by
Author Amanda Walton

I really enjoyed the voice of the narrator, she speaks in a soothing tone. The book is a really great reminder of things we might have known we could do during stressful times, but forgot over the years.

Author Harmony Hawaii

There is so much waste in our society today. Everyone should be forced to read this book. I know I am passing it on to my family.

50 Things to Know to Downsize Your Life: How To Downsize, Organize, And Get Back to Basics

Author Lisa Rusczyk Ed. D.

Great book to get you motivated and understand why you may be losing motivation. Great for that person who wants to start getting healthy, or just for you when you need motivation while having an established workout routine.

50 Things To Know To Stick With A Workout: Motivational Tips To Start The New You Today

Author Sarah Hughes

50 THINGS TO KNOW ABOUT CANVA

How to Create Beautiful Custom Images

Anna Compagine Cohen

Cover designed by: Ivana Stamenkovic
Cover Image: https://pixabay.com/photos/color-fan-pantone-
printing-inks-541624/
Editor: Max Cohen

CZYK Publishing Since 2011.
CZYKPublishing.com
50 Things to Know

Lock Haven, PA
All rights reserved.
ISBN: 9798722309785

50 THINGS TO KNOW ABOUT ABOUT CANVA

BOOK DESCRIPTION

Do you want to spice up your social media posts? Do you wish you could create beautiful graphics quickly and easily? Are you ready to start using Canva right away to create compelling designs? If you answered yes to any of these questions then this book is for you!

50 Things to Know About Canva by author Anna Compagine Cohen offers a detailed, step-by-step approach to learning Canva. Most books on Canva are heavily focused on graphic design principles. And although there's nothing wrong with that, this book is here to hold your hand and guide you through the entire process, from signing up for your account all the way to sharing your designs with the world.

In these pages you'll discover how to get started with Canva right away. You'll learn how to combine images, text, and elements to create gorgeous, attention-grabbing visual pieces.

By the time you finish this book, you will know exactly how to develop designs that you can print or share on social media. So grab YOUR copy today. You'll be glad you did.

TABLE OF CONTENTS

50 Things to Know

Book Series

Reviews from Readers

50 Things to Know About About Canva

BOOK DESCRIPTION

TABLE OF CONTENTS

DEDICATION

ABOUT THE AUTHOR

ABOUT THE Editor

INTRODUCTION

Getting Started

1. What is Canva?

2. So Who Exactly Should Be Using Canva?

3. How to Open Your Canva Account

4. Free Vs. Paid Canva Account

5. Navigating the Home Page

Creating Your First Design

6. How To Choose A Design

7. Name Your Design

8. Going Back to Your Design

9. All About Templates

10. Working With The Page Layout

11. How Layers Work

12. Grouping

13. Aligning

14. Locking Layers Into Place

15. More Options on the Design Navigation Bar

Choosing Your Background

16. How to Change the Background Color

17. Setting a Background Image

18. Using a Photo as a Background Image

Working with Text

19. Adding Text

20. Choosing a Font

21. Editing Text

22. How to Change Font Spacing

23. Aligning Text Boxes

24. Creating Text Masks

All About Photos

25. How to Add Photos to an Image

26. Uploading Photos

27. Resizing and Cropping Photos

28. Photo Editing Tools

29. Photo Filters and Adjustments

Playing with Elements

30. What are Elements

31. Using Lines

32. Using Shapes

33. Frames

34. Stickers

35. Charts

36. Grids

37. Gradients

Adding Special Effects

38. Animating Designs

39. Adding Audio to Your Design

After You've Finished Your Design

40. Sharing Your Design with Collaborators

41. Sharing Your Final Design Via Social Media

42. Downloading

43. Professional Printing

Extra Tips & Tricks

44. Tips for Flyers

45. Tips for Social Media

46. Tips for a Zoom background

47. Using Folders

48. Canva's Palette Generator

49. Upgrading to a Free Canva Account

50. Using the Canva App

Bonus: Design Tips

BONUS TIP 1: Design Tip 1: Color Theory

BONUS TIP 2: Design Tip 2: Typography

Other Resources:

50 Things to Know

DEDICATION

This book is dedicated to my two greatest loves - my sons, Max and Freddie. They have championed and supported my writing career since day one. They are my inspiration and my biggest cheerleaders.

If they learn nothing else from me, I want them to know that you're never too old to follow your dreams - not even the wildest ones, the ones you hide in the depths of your soul. Be brave and listen to your heart; it's the only way to find happiness.

ABOUT THE AUTHOR

Anna Compagine Cohen is a writer, designer, and dreamer. She is passionate about delighting her readers with juicy content and gorgeous graphics.

Anna has worked in the worlds of Marketing and Advertising for over 20 years. In that time, she has used many of the industry's top professional design programs. But Anna fell in love with Canva when she realized how quickly and easily she could create beautiful, dynamic, custom images. She has been sharing her knowledge of Canva with family, friends, and strangers, teaching workshops and creating online Canva courses.

When she's not writing, Anna spends her free time walking on the beach or spoiling her two teenage boys and their two unruly puppies. Anna loves travel and daydreams of spending her summers exploring foreign countries. You can follow her adventures on her blog, leggingsandlaptops.com, or on instagram @leggingsandlaptops.

ABOUT THE EDITOR

Max Cohen is a poet, novelist, and editor. His love of wordsmithing shines through with every slash of his red pen. Max dreams of traveling the world as a freelance author and editor. You can read Max's work at maxcohenwriting.com

INTRODUCTION

"You can't use up creativity. The more you use, the more you have."

Maya Angelou

I have worked with and learned from top-notch graphic designers; each of them has taught me something about their craft. But it wasn't until I fell in love with Canva that it all just clicked together. Having access to free templates and stock photography is just the beginning. Canva has helped me become a better designer, as I navigate easily through fonts, hex colors, and elements. Every time I use Canva, I discover a new feature that makes my job easier and my designs more spectacular.

My hope for you is that, as you explore Canva, you too will feel its allure and choose it as your go-to design program. Go create something beautiful!

GETTING STARTED

1. WHAT IS CANVA?

Canva is a free online software program that anyone can use. It can be used to create a wide variety of both print and digital materials, for personal or business usage. You can use Canva on the weekend to create a click-worthy instagram story, then use it Monday morning at work to design a brochure. It's that flexible and just as easy to use.

2. SO WHO EXACTLY SHOULD BE USING CANVA?

Canva is for anyone who needs or wants to create beautiful and easy graphic designs. Students can create graphics, including pie charts and graphs, that will level up their reports. Entrepreneurs and small business owners can use Canva to create a logo, pick branding colors and fonts, and then create multimedia designs. Social media addicts can create posts and stories. Marketing teams can collaborate on campaigns. You can even use Canva to create party invitations or holiday cards.

3. HOW TO OPEN YOUR CANVA ACCOUNT

Opening your Canva account is free and easy! Simply go to the Canva website, www.canva.com and click on the box in the top right-hand corner that says "Sign up." You will be given the option to sign in via Google, Facebook, or just use your email address and a password. The method you choose is up to you; they all work exactly the same once you have an account. However, if you use Google Chrome as your browser, creating your account via Google will keep you signed in easily across multiple devices.

The next thing you will have to do is let Canva know your primary use. Don't stress about it too much. Doing this will allow Canva to suggest templates or projects for you, but you can still access all of the features regardless of what you choose here. If you are just playing around and learning the software, go ahead and click on "Personal" and you'll be ready to go!

4. FREE VS. PAID CANVA ACCOUNT

The next thing that you will have to decide is whether you want to sign up for a free account, or sign up for a free trial of the paid account. My recommendation right now is to choose the free account. For one thing, everything we go over in this book will be based on a free Canva account, so you won't be missing out on anything.

Also, the free trial will only last for thirty days. If you are just learning Canva, it can easily take you that long to learn the free features. Signing up now for a paid account means you will be wasting at least some of your free trial period just learning how to use the software. Wait until you have explored everything you can do in Canva for free. Once you are comfortable with the free version, go ahead and upgrade to the paid version so you can compare and decide whether the added features are worth the cost for you.

5. NAVIGATING THE HOME PAGE

Once you have signed up for your free account, you can explore Canva's home page. Canva offers many useful resources.

Looking at the navigation at the top of the page from left to right, your first drop-down menu will be for templates. We will discuss these in more detail later. For now, just notice the categories available to you: Social Media, Personal, Business, Marketing, Education, and Trending.

The next button is Features. Here, you can look at Photos, Icons, Print Products, Apps, or Explore. Something to keep in mind is that, since you are using the free version of Canva, not all of the photos and icons (small graphics) will be unlocked for your use. It can be frustrating to find a photo or icon you love and realize it's not free! To avoid that, make sure you use the drop down menu in the photo or icon search to select the option "Free."

While you're here, take a moment to look at options for printing your designs. You can even create a tee shirt or mug directly from Canva.

CREATING YOUR FIRST DESIGN

6. HOW TO CHOOSE A DESIGN

Now that you are a little more comfortable with the Canva home page, let's start by choosing your first project.

There are several ways to do this. The first is to simply go to the top of the home page, where the search bar is. Once you click on it, before you even start typing, some suggestions will pop up. You can click on one any of these to begin designing. Or, you can type in the project you would like to create, such as a flyer or Facebook ad.

If you have a specific project size in mind, for example, if you are designing a 5x7 greeting card, enter or click on Custom in the search menu. Here you can enter specific dimensions in pixels or in inches.

You can also scroll through the design options underneath the welcome banner. Here you will see options for social media, school projects, flyers, postcards, brochures, blog banners, calendars and more.

Once you've decided on your project, go ahead and click on it so you can begin playing with Canva!

7. NAME YOUR DESIGN

The first thing you want to do is give your design a name. There is a blue navigation bar at the very top of the page. In the middle/right of that top bar, you will see where you can enter the file name. Until you enter something, it will display "Untitled Design." Click in that box and enter the name of your design.

Here you will want to be descriptive as possible so that you can tell at a glance exactly what the project is. I also recommend that you enter the date, so that if you do several versions of the same design you can see which is the most recent. Also, if you are making designs for multimedia use (i.e. a Facebook post, an Instagram story, and an email graphic), they will probably have to be different sizes, so you will want to enter the media usage in the title, as well.

Here is an example of a bad title choice: "Banner." What would I use instead? I would title it "LinkedIn Personal Banner Jan. 2021." This will come in handy when you have dozens of designs; you will be able to tell at a glance which is which without having to open them.

8. GOING BACK TO YOUR DESIGN

Sometimes you will shut down Canva and walk away from your computer. When you return, you need to know where to find your designs.

Go to the Canva homepage and log in. On the left hand side, you'll see a list of options. Click on "All your designs." This will take you to a page that displays all of your work in Canva in chronological order. Scroll down to one you want to edit and click on it. Your design will open in a new tab.

When you edit your design and save it, the previous version will no longer exist. So if you aren't sure that you want to erase the current version, you can make a copy instead of editing. Hover your cursor over the design. You will see three little dots pop up. Click on them, then click on "Make a copy."

The copy of your design will now be at the top of your list of designs, and be titled "Copy of… [file name]." You can work in that without making any changes to the original file.

Of course, if you are editing a file and change your mind, you can undo your changes. Click on the left-curving arrow at the top of the page or use Ctrl+Z to undo.

9. ALL ABOUT TEMPLATES

When you first looked at Canva, one of the options we passed over was the Templates option.

Templates are basically premade designs that you can use for your projects. You can find them on the Canva home page. On the top navigation bar, hover your cursor over the word "Templates." You will see the options for many different templates, sorted by type: Social Media, Personal, Business, Marketing, Education, and Trending. Those categories break down even further, so you can find templates for everything from an instagram post to a flyer to a certificate.

Find the project you want to design, and click on the correct template. You will be taken to a page with all of the different options for that template. You can even break it down further with additional filters. Once you've found one that you want to use, click on it and your design will open in a new window.

For the most part, templates can be edited. You can change colors, images, fonts, and even the layout to suit your needs.

10. WORKING WITH THE PAGE LAYOUT

If you click on "File" on the left side of the top navigation bar, you will get the option to adjust some of the page layout.

Show Rulers: Under this option, you will see rulers at the top and left margins of your design. This can come in helpful if you know exactly where you want to position an object. Take your cursor over to one of the rulers. When it becomes a double-sided arrow, you can drag and drop it at a precise spot in your design. This can help you know exactly where to place the elements.

Show Guides: The line you just created is known as a guide. When you dragged it over, it automatically enabled the "Show Guides" option. If the guides are making it difficult for you to really focus on your design, you can uncheck this option and the guide will be invisible. It's still there, though, so checking that option again will show the guides right where you had them.

Show Margins: This option shows the margins of a standard printer. Most printers don't have the capacity to print all the way to the edge of the paper, so this will give you an idea of where the edges of your graphics, text, etc. should be. Keep all of your

elements within the margins so they aren't cut off when printed.

Show Print Bleed: When this is checked, you will see the absolute limits of a printer. It goes beyond the margin, so that there won't be a white space around your design when it is trimmed. This is usually only used with professional printing.

11. HOW LAYERS WORK

In Canva, each element (text, images, graphics, shapes, etc.) of your design is set up in its own layer. Think of each layer as a differently sized piece of paper. You can shuffle them around and decide which paper to put on top of which. For example, you will usually want to put the text over an image or photograph.

Canva organizes its layers in the order you add them. Say you added the text, and then a photo. When you try to overlap them, the photo will be on top of the text. If you want to change that and have the text on top, you will have to adjust that manually.

Click on the element you want to change to select it. Then click on "Position" at the top of your design. You can bring that element forward or backward. If you are working with several layers, you will have to click on forward/backward for each.

12. GROUPING

Sometimes when you are working with different elements you might want to group them together. This locks them into place relative to one another. When this happens, you won't be able to move one image without moving the rest.

To select the elements you want to group, click on the first one and shift+click on the others. Then click on "Group" at the top of your design. Now, if you move one element, the others follow in the exact same positioning.

If at any point you need to ungroup those elements, click on any one of them and then click "Ungroup" at the top of your design.

13. ALIGNING

Canva has made it easy for you to align the elements in your design. Click to select an element, then on "Position" at the top of the page. You can align it vertically: top, bottom, or middle of the page. Or you can align it horizontally: left, right, or center of the page.

You can also align a group of elements relative to one another quite easily. Select each element, then click

on "Position." You can then choose to align them vertically or horizontally. You can also choose "Tidy up" and let Canva choose how to best organize them for you.

14. LOCKING LAYERS INTO PLACE

When you are working with a large number of layers, sometimes you will find that you thought you were moving one layer but actually moved a different one. This can be very frustrating, especially if it had taken you a while to position that layer exactly where you need it to be.

To avoid that, Canva will allow you to lock a layer into place. Select your layer by clicking on it, then click on the image of an unlocked padlock on the top right of your design. That element is now locked in place and cannot be moved.

If for any reason you decide you do need to move that layer, you can select it and then click on the locked padlock.

15. MORE OPTIONS ON THE DESIGN NAVIGATION BAR

There are a couple of other items on the design navigation bar that you should be familiar with.

Copy Style: This is the option that looks like a paint roller. Click on an element, then click on the paint roller, and click on a different element. The properties of the first element you selected will automatically be given to the second one.

Transparency: This option looks like a fading checkerboard. First click on a layer to select it, then click on this checkerboard. You can now adjust the transparency of the selected image, text, or shape. The number is a percentage, so the higher the number the less transparent it will be. Transparency of 0 will be completely transparent, aka not visible at all.

Link: If you click a layer and then click on the image of a link, you can add a link to an outside web page.

Duplicate: Those two boxes, with a plus sign on the front one, will make a duplicate of the selected element.

Delete: The trash can will delete a selected element.

Most of these work exactly the same if you pick a group or a set of elements.

CHOOSING YOUR BACKGROUND

16. HOW TO CHANGE THE BACKGROUND COLOR

The first thing you will want to do is choose your background. It's the foundation on which you will build your Canva house. So make sure that you pick colors that are easy on the eye but that also fit in with the brand's logo, tone, messaging, etc.

To begin, first create a new design. All the way to the left, you will find a black and gray navigation bar. Click on bkground. This will open up pictures and solid colors. You can scroll through and click on whatever color you like. This is now your background color.

If you don't like any of the color choices, you can click on the white/light gray artist's palette. You can use one of the default colors or click on "New color."

If you select "New color," you can choose any color by sliding the white dot along the color spectrum. Or, if you know the color's hex number, you can enter it in the space provided. Remember you can always use CTRL+Z to undo any changes you don't wish to keep.

The background color can be changed at any time during the design process. It is always the bottom layer of your design, and the color you select will cover your design completely.

17. SETTING A BACKGROUND IMAGE

Sometimes you may want to use a background image instead of a solid color. On the left-hand navigation bar, click on "Bkground." You will see some category choices here, such as landscapes, textures, and nature. You can select on one of these to see more options.

You can also use the search bar at the top of the background options to find a specific image. For example, you can enter "sunset" or "ocean" to narrow your search. These can be edited just like a photograph, and we'll go over that later in the Photo Editing section.

If you aren't sure what image you want, but do know the color, you can enter the color into the search bar. This will show you all of the images that contain that color for you to scroll through. You can also enter the word "gradient" and search through multi-hued options.

Once you have found an image you would like to use, all you have to do is click on it and it will become the background image. You can change your background image at any time during the design process.

18. USING A PHOTO AS A BACKGROUND IMAGE

If you couldn't find a background image you liked in the background options, you can also choose a regular photo. Canva has thousands of photos available for you to use for free.

On the left-hand navigation menu, click on "Photos." You can scroll down for the top trending photos. Or, you can scroll across the menu at the top for different photo categories.

If you know what you want, you can use the search bar at the top to filter your options. This will make it easier to scroll for, say, a photograph of a skyline.

Once you've found the photograph you want to use as your background, you can add it in one of two ways. First, you can click on it and it will be added to your design. You can then use the resizing handles, found on the corners of the photograph, to make it large enough to cover the entire design, as a background image should.

You can also drag the photo over to your design. When it covers the entire layout, release the photograph and it will become the background image.

Most of the time, your photograph will not be sized the same way as your design. For example, if you are using a landscape-oriented photo as the background for an instagram (square) design, the photo will be wider than your design, so parts of it will be cut off. You can double-click on the photo and then drag it around your design, adjusting which parts of the photo will be displayed.

WORKING WITH TEXT

19. ADDING TEXT

Once you have set your background image, your next step will be to add text. Click on "Text" on the left-hand navigation bar. You can choose to add a heading, subheading, or body text. Don't worry too much about which one you choose, because you can change font and font size to make it look however you'd like.

Click on any one of the options, and a text box will be added to your design. Select the text that is automatically entered into the box, delete it, and write whatever you'd like. You can enter all of your text into one box, or add multiple text boxes that you will position in different parts of your design.

If you click on the text box, you can then drag it wherever you'd like on your design. You can also hover your cursor over the turn icon (two curved arrows that make a circle) and use that to change the orientation of our text, making it diagonal or even vertical instead of horizontal.

20. CHOOSING A FONT

Once you have entered your text, you can change the font you are using. Click on the text box, and a menu will open at the top of your design that shows the current font. If you click on the down arrow, a new menu will open up, to the left, that shows all of your font options.

The font names are written in the actual font, so you will see what they look like. You can scroll through the list to find the font you like.

There is also a search bar at the top. You can enter a font name, such as Nexa, to see the options: Nexa Light, Nexa Bold, Nexa Script, Nexa Slab, etc. You can also enter a type of font, such as calligraphy or serif, and scroll through options.

Once you have found a font you want to use, simply click on the name to change the font in your text box.

21. EDITING TEXT

Once you have written out the text and chosen the font, you can edit your text to get it to look just the way you want. Most of the font editing tools are found in the navigation bar at the top of your design.

The number at the top is the font size. You can adjust it up or down to make your text larger or smaller. The letter A with the rainbow underneath is where you can change the font color. If you click on it, you will see some suggested document colors. These are suggested as a match to other elements in your design. Or, you can click on "new color" to open the color spectrum. Here you can use your cursor to choose a color, or enter a hex number if you know it. You can also click the B or I to make your text bold or italicized, although not every font will offer you those options.

You can also use the top navigation bar to change the alignment (left, right, center, or justified) or to make your content a list.

If you click on "Effects" (the last button on the right), you will see options for making your text more fun. These include curving your font, making your text hollow, or adding a drop shadow.

22. HOW TO CHANGE FONT SPACING

In general, this is not something you want to do. Font designers are professionals who spend much time adjusting their font design for it to look just right. Changing the spacing can make it look awkward and not as well-designed. However, there are times when you will want to adjust spacing.

On the navigation bar at the top of your design, click on the spacing button (three horizontal lines with a double-sided arrow). You can use the menu that pops up to adjust the space in between letters or the spacing in between lines.

23. ALIGNING TEXT BOXES

Aligning text boxes is the same as aligning any other element. You can drag them around or click on "Position" (under the 3 black dots in the top navigation bar) to align them to the page.

But sometimes you will want to align your text boxes to one another different. This is when manual alignment can be useful.

Select the first text box and place it exactly where you want. Then click and drag the second text box. You

will see purple alignment lines when you line up the two boxes. Horizontally, the lines are top, center, and bottom. Vertically, the lines are left, center, and right. You can use these lines as a guide to line up text boxes however you'd like.

24. CREATING TEXT MASKS

A text mask is when text is filled with an image instead of being a solid color or hollow. Using text masks can create really beautiful and unique designs.

To create a text mask, first click on "Elements" in the left-hand navigation bar. Scroll down and click on "Frames." When you scroll down the frame options, you will eventually come to letters. Go ahead and click on each letter you want to use in the text masking to add them to your design, but try to keep it to short words or phrases.

Adjust the size and alignment of the letters however you'd like. Once all of the letter frames are set, you can add the text masking. Click on "Photos" and scroll or use the search bar to find the photo(s) you want to use. Then simply drag and drop the photo to each letter. You can click on the photos to make them bigger or move them around, so that different letters show different sections of the image.

ALL ABOUT PHOTOS

25. HOW TO ADD PHOTOS TO AN IMAGE

The next element you'll want to add to your design is a photograph, or several of them. On the left-hand navigation bar, click on "Photos." Here you can scroll through some of Canva's most popular categories to find a picture that goes with your design. You can also enter a description ("cloudy sky") or color ("dark blue") in the search bar for filtered options.

When you find the photo you want to use, click on it or drag and drop it to add it to your design.

Some pictures will not be available for you to use because they only come with a free account. The photos are marked with a small crown in the lower right corner. You can insert them in your design, but they are watermarked. You will have to pay a small fee before you can download the image.

26. UPLOADING PHOTOS

If you can't find an image that you like, you can use a photograph of your own or a free stock photo. If you

are using stock photography, be very careful with copyright laws and usage regulations!

To use your own photograph as a background image, first you have to upload it. On the left-hand navigation bar, click on "Uploads" then click on the purple "Upload media" button. From here, you can pick where the photograph will come from and search the files until you find it.

Once the photo is uploaded, it will now be available under the "Uploads" tab. You can click on it to add it to your design, or drag it over.

You can also use a photograph of your own as a background image. Drag it over to your design, and release it when you see it take up the entire frame.

27. RESIZING AND CROPPING PHOTOS

Once you have added a photo to your design, you can resize or crop it as needed to make it look just right.

To resize the photo, click on it to select the image. In each corner, you will see a white circle. Select one and drag it diagonally to make the image bigger or smaller.

To crop a photo, click on the image to select it. You will see a white bar on each side (top, bottom, left, and right) of the photo. Pick one and drag it straight in to crop the photo. You will see that as you drag in the handle, the part of the image you have gone past is no longer visible.

If you want to crop and drag at the same time, select the image and then click on "Crop" in the top navigation bar. You can change the image size and then move the photo around within the new size to display as you'd like.

28. PHOTO EDITING TOOLS

Once you have your photo in the proper position and sized correctly, you can start editing. Your photo editing tools are in the top navigation bar. If you click on "Effects," you will see the special effects apps that you can connect to. These apps offer cool renderings such as pixelating and retro finishes. Bear in mind that these are all third party apps, so you will have to connect to each of them and accept their terms and conditions. But they can add some very fun effects to your pictures, from pixelating to blurring and even adding quirky frames and angled shadows.

One effect that might be very useful is the smart mockup. With this, you can see your image added to a

laptop, phone, framed print, tee shirt, etc. These can be very useful if you are using Canva to sell products.

29. PHOTO FILTERS AND ADJUSTMENTS

Photo filters in Canva are very similar to the ones you can use on Instagram. Adjustments are practically identical to those found in any other editing app, including the ones on your phone, they are just more advanced.

Click on the image you want to edit, then click on "Filter" in the top navigation bar. This will open a menu that shows you all of the available filters and how they change your photo. Click on the one you want to use and it will be automatically added to your photo. You can also adjust the intensity of any of the filters, from barely noticeable to heavily filtered.

If you want to tweak the color settings of an image, click on it and then click on "Adjust" in the top navigation bar. You can use the slider to adjust the brightness, contrast, saturation, tint, blur, x-process, and vignette of any image.

PLAYING WITH ELEMENTS

30. WHAT ARE ELEMENTS

You can make your designs more fun and personalized using elements. Elements are like embellishments or decorations that customize your design. Some elements are fun and quirky and others are more elegant or professional. When you choose an element, make sure you are thinking of your audience, theme, and purpose for your design so that it keeps a cohesive tone.

On the left hand navigation bar, click "Elements." This will open a menu with all of the element categories: lines, shapes, frames, stickers, designs for a cause, charts, grids, gradients, and then seasonal or trending elements.

Most elements are free, but some of them will have a small white crown on the corner. Those elements are free for premium (paid) Canva accounts. If you want to use them, you will have to pay a small fee (usually $1) per usage.

Elements in the Design for a Cause category are meant to raise money for a specific charity, so none of those are free. If you like one of those, you can click on it to find out how much it costs and what charity your money would go to.

To find an element, you can scroll through and click on a category, or enter a word or phrase into the search bar at the top. When you find an element you like, just click on it and it will be added to your design.

31. USING LINES

Lines and shapes are the two most basic forms of elements. To use them, click on "Elements" and then scroll down to whichever category you are interested in.

Lines are a great way to break up a design. They can be used to divide text blocks, for example, to make it easier to tell when one section ends and the next one begins. When you click on a line, it will be added to your design. Once you have added a line to your page, you can drag it to wherever you'd like. You can also rotate the line. Click on it to select it, and you will see a circle with two curved arrows underneath. Click on that and drag your cursor left or right to change the angle.

Then you can edit the line. You can change the color and length of almost every line. To adjust the length, click on the line and then use the circles, squares, or arrows on the end of the line to drag it as long or as short as you'd like. You can also change the color of

a line. When you click on it, the top navigation bar will show a colored square. The color in the square is the current color of your line. Click on that square, and you can enter a color name or hex number, or click on the spectrum to select a new number.

Every line is different, so some of them can also be edited in other ways. Your options will be found on the top navigation bar. Some common options include changing the end shape of a line (arrow, circle, etc.), the style of the line (solid, dotted, dashed), or the line weight (thickness). For highly stylized lines, though, you might not have any options other than color and length.

Note that not all lines are straight - some are fun swirls that end in an arrow.

32. USING SHAPES

You can also add shapes to your design. There are the standard shapes, everything from squares to hexagons, as well as more ornate shapes such as frames, callouts, and zigzags. To find the shape you want to use, click on "Elements" and then click on "Shapes." You can either scroll down or enter a shape into the search bar.

When you find the shape you want to use, click on it or drag it over to your design. You can then edit the shape. To change its size but keep the same scale, click on the shape, then drag the circles in the corner in or out diagonally to resize it. You can also adjust the height or width of the shape by dragging the bars on the sides in or out to narrow or widen it. Note: not all shapes can be adjusted both ways. Some can only be resized at scale.

You can also change the color of the shape by clicking on the black box at the top of the design window. This will open up the color selection tools.

33. FRAMES

Frames are not what you would think. They are not hollowed frames that you can use for your pictures (those are found under "Shapes" or "Stickers"). Instead, frames are solid shapes that hold a picture.

Click on "Elements" in the left hand navigation and then click on "Frames." You can scroll through to see the different frames. Some of them are classic shapes, such as squares or circles. Others are much more stylized, looking like teardrops, cell phone screens, camera film, and more. This is also where you can get numbers and letters for text masking effects.

One you find the frame you want to use, click on it or drag it over to your design. You can resize it just like you would a shape. Then go over to "Photos" on left hand navigation and find the photo you want to use inside the frame. Drag and drop it into the frame. You can then resize the photo or use any of the Canva photo effects to enhance your image.

34. STICKERS

Stickers are basically illustrations that you can add to your design. When you click on "Elements" and then on "Stickers," you can scroll through all of the most recent and most popular ones. You can also enter a color, holiday, or subject matter into the search bar to find the sticker you'd like to use.

Many of the Canva stickers are free, but you will come across quite a few that aren't. Stickers that are only available with the paid version of Canva are marked with a small white crown. They will cost around $1 every time you use them, just as the others.

Once you have found the sticker you would like to use, you can click on it or drag it over to your design. You can then resize, crop, flip, and edit your sticker. Some stickers will also let you change their colors. If that is an option for you, you will see a series of boxes at the top navigation bar, each containing a

color that comes from your sticker - the more complicated the sticker, the more colors you will have to change. Click on each color to open up the color spectrum and adjust the current colors. Note: not all stickers will allow you to change colors. If your sticker doesn't show the navigation bar, then those colors are set.

35. CHARTS

The chart elements are perfect for spicing up any presentation. Click on "Elements" and then "Charts." This will show you all of the available graphics you can use here. There are bar charts, pie charts, progress bars, line graphs, and more. Canva even includes other images that you might want for your charts, such as clipboards, checkmarks, thumbs up, etc.

When you find the type of chart you want to include, click on it or drag it over to your design. For most of the charts, you can adjust the colors and make a few other tweaks, such as the thickness of the line. In general, you can also change the colors used in the chart.

Once you are happy with the location, size, color, etc. of the chart, you can enter the data. Click on the chart to select it and then click "Edit" in the top navigation

bar. You will have a table pop up, and can enter numbers manually or paste them from a spreadsheet.

36. GRIDS

Grids are very similar to frames in that they hold photo elements. However, unlike frames, grids are designed to hold multiple images. Think of them as a collage.

Grids are meant to take up the entire design. You can click on a grid or drag it, and it will automatically expand to fill up your entire design. They can be resized, however, by clicking on it and using the handles to resize it horizontally, vertically, or diagonally (scaled).

Once you've sized your grid and moved it where you'd like in your design, you can add photos. Click on "Photos" in the left hand navigation bar to choose from Canva's stock photos, or upload images from your device.

After you add a photo to a frame, you can edit it as you would a regular photo. Click on it to select it, and you will have access to all of the photo editing tools. You can also double-click on the image to drag it around within the frame.

37. GRADIENTS

Gradients are images that fade from one color to another. The gradients in Canva range from traditional shapes (squares, circles) and more stylized shapes (brushstrokes, geometric shapes).

To add a gradient to your design, click on "Elements" and then "Gradients." Scroll through to find the one you like, then click on it or drag it over to your design. You can then resize the gradient, just as you would any other shape.

After that, you can change the colors used in the gradient. Click on the gradient in your design to select it. Depending on the gradient style, you will usually see between two and four color boxes in the top navigation bar. You can click on each of those and use the color spectrum to change them.

ADDING SPECIAL EFFECTS

38. ANIMATING DESIGNS

If your design is going to be used in a slide or posted online, you also animate the layers. The effect will be very similar to the animations done by PowerPoint.

To add animation, click anywhere on your design. Then click on 'Animate" in the top navigation bar. This will animate all of the elements on your page. You will be able to try on some of the different animations to see which one works best for your design. You can also change the timing, so the effect takes longer or goes more quickly, depending on what you prefer. In general, you should stick to faster animation times. If it takes too long to cycle through the animation, then it will hardly be noticeable.

39. ADDING AUDIO TO YOUR DESIGN

If you are going to post your design online or share it on social media, you can even add audio through Canva. Audio is not available for all designs, but it is available for: social media, ads, presentations, videos, websites, invitations, announcements, and programs.

Click on "Audio" in the side panel. Scroll through the audio categories, use the search bar, or click "see all" in a category. Click on any thumbnail to listen to that track. When you've found the one you want to use, click on the track name to add it to your design.

The length of the track will default to 5 seconds if you have no animation. If your design is animated, then the track will play for the duration of the animation. If you want to trim the track, click on the name of the track (located in a button at the bottom of your design). This will display the track in the navigation bar at the top of your bar. The length of the sound bite is in blue, and the rest of the track - the parts you won't hear - are grayed out. Click and drag the blue section along the track to select a different section of the audio.

AFTER YOU'VE FINISHED YOUR DESIGN

40. SHARING YOUR DESIGN WITH COLLABORATORS

The next step is sharing your design with others for opinions, feedback, and collaboration. . Canva gives you quite a few options for sharing your design, and you can control whether you share it for viewing only (they can't make changes) or with permission to edit.

First, you might want to share your design with a business partner, collaborator, editor, or friend. To share with just one person, click "Share" on the right-hand side of the purple navigation bar. Enter that person's email address, and use the drop-down menu to decide whether they can view your design or edit it. If they edit it, your original design (the version prior to their changes) will be lost, so be certain that you are comfortable with letting them edit. You might want to save a copy of your original design and send them that, instead. Add a message if you'd like, then click "send" and they will receive your design.

You may also want to create a team, so that you can work together on a design in real time. This team can have permission to view only or to edit. You can change team options from design to design, if you work with multiple clients for example. To set up a

team, go to the Canva home page. You click on "Create a Team" in the left hand navigation bar. From there, you can enter the email addresses of your team members, choose what access you'd like them to have, and send them invitations.

You can also use the "Share" option to copy the link, and decide whether the link is for viewing, editing, or using as a template.

41. SHARING YOUR FINAL DESIGN VIA SOCIAL MEDIA

Once you are done incorporating feedback from others, then that's it! You've completed your design, congratulations! You are now ready to share your design with the world.

Click on the three horizontal dots in the top navigation bar. When you scroll down a bit, you will see the options for sharing. You can link your Canva account to your social media accounts and publish directly to Facebook, Instagram, LinkedIn, Mailchimp, and more. You can also share it via Dropbox, Google Drive, Microsoft One Drive, etc.

42. DOWNLOADING

You can also download the design to your device so you can print, post, or share it yourself. On the top navigation bar, click on the download button (an arrow pointing down). Canva will suggest the best file formats for downloading your image. Generally speaking, you will want to download a PDF if you will be printing a flyer, brochure, postcard, etc. If you are printing an image, a PNG is a larger file and will have a better print quality. And a JPG or GIF will work best for online usage, since they are smaller files and won't take as long to load.

43. PROFESSIONAL PRINTING

Depending on what you have designed, you can also choose printing options for professional printing. Some of these printing options are for gift purposes, such as mugs and tee shirts. Others will be home decor, including posters and canvases. And you can also choose to print business products such as brochures, flyers, postcards, or promotional stickers. You can even print photo books, if you created a design with multiple pages.

Usually, when you opt for a special print job, Canva will have you click on "Resize design" to make sure

your design prints correctly. Depending on the final product, you can then choose other options such as quantity, finish (matte vs. glossy), paper quality, etc.

Canva will walk you through the entire process, including making sure the design stretches all the way to the edges of the paper and that all images are high enough quality to print without blurring. Finally, when it's all set up, you can pay for your printing and Canva will deliver it to you.

EXTRA TIPS & TRICKS

44. TIPS FOR FLYERS

When you create a flyer, the default size is half of a page, you will have to manually adjust the size to be 8.5 x 11. Also, make sure that your background image or color goes all the way to the edge of the paper. Even though a home printer will leave a margin, it will look better than if you leave too much white space. Also, bring any important text or images away from the edges of the page, so that it doesn't get cut off by your printer.

One design tip: when you design your flyer, include an attention-getting headline. It's the only way you'll get people to read the rest of your flyer.

45. TIPS FOR SOCIAL MEDIA

Canva has a large number of options for creating quick and easy social media posts. When you go to create a design, enter the social media you want to use to see all of the possibilities. For example, if you enter "Facebook," you will see options such as Facebook ad, Facebook app ad, Facebook, cover, etc.

Select the one you want to use and it will open in a new tab.

Once you have a design open, click on "Templates" in the sidebar. Then use the search bar and enter "quotes," "food," "fitness," or anything else you might want to create to get design ideas for your post. Even if you don't use the actual template, they are great for inspiration.

You can also use Canva for your instagram story. Templates here can also include quizzes, questions, and polls - you can use the search bar to find templates for any of those.

And don't forget to use the "Animate" option for dynamic and fun social media posts. Animation can be eye-catching when someone is scrolling, so use it (but don't overuse it!).

46. TIPS FOR A ZOOM BACKGROUND

Zoom has become so popular! Friends, family, work: everyone is using Zoom. But maybe you don't want everyone getting a "sneak peek" into your home, which is understandable. Zoom does offer a very few "green screen" backgrounds for you to use. But you

can create something much more beautiful and even fun using Canva!

There are some templates on Canva to choose from. When you go to create your design, choose "Zoom Background." Your design will open in a new window. There will be options in the sidebar for Zoom templates. You can choose one of these and edit them as you would any other design. Or, you can create your own Zoom background, using the custom size 1280 x 720.

When you create a Zoom background, try to keep it to something more simple. You don't want to "get lost" in a busy design!

47. USING FOLDERS

One of the great organizational tools within Canva is its folder section. From the Canva home page, click on "All your folders." This will contain a number of folders that were already created. One important one to note is the "Trash" folder. If you delete a design and change your mind, you can go to this folder to recover it.

You can also create your own folders. If you use Canva long enough, you will have so many designs. Keeping them organized in your folders will save you

time scrolling through the homepage to find them. With the free Canva account, you can have two folders.

48. CANVA'S PALETTE GENERATOR

One of Canva's most convenient tools is its palette generator. From the Canva homepage, click on "Features." Scroll all the way to the bottom, and under the list of resources, click on "Palette generator." This will help you find the perfect colors to use with your image! Simply upload the image, and Canva will create a 4-color palette that you can use for elements, text, background, etc. The hex numbers will be right below each color, so you can enter them in the color spectrum of your design, or you can click on a color and it will automatically copy the hex number to your clipboard.

49. UPGRADING TO A FREE CANVA ACCOUNT

Once you have been playing with Canva for a while, you can try out there Canva Pro to see if it is worth having. You can get a free 30-day trial of the pro version, but I would suggest you wait until you're

really good at Canva, so you can judge if you'll need it. I used the regular Canva for years before I switched to pro!

There are two features with Canva Pro that are worth the money. First, everything is free. Every stock photo, template, font, element, all of it. So if you are paying $1 here and $1 there, and it is adding up, the pro version is worth it. Also, if you use various social media accounts, there is one feature of Canva pro that you will love: the resize option. You can make a design for one social media account, for example, Facebook, and then resize it to use it for a Facebook ad. It saves time and effort and is one of my favorite features of Canva Pro.

50. USING THE CANVA APP

Canva does have an app available for downloading on both Android and iOS. The app isn't as robust as the online version, however, so keep that in mind. It is handy, though, for any designs and uploads that you want to finish on-the-go. The best way to use it is in conjunction with the website. For example, if you want to blast out a food post, you can design the majority of it on the Canva website. Then when you go to the restaurant, just snap a picture of your meal, drop it into the app, and share it on social media.

BONUS: DESIGN TIPS

BONUS TIP 1: DESIGN TIP 1: COLOR THEORY

If you want your design to look professional and cohesive, you should use no more than 1 main color and 2-3 accent colors, maximum. The smaller the design (i.e. an instagram post), the less colors you want to use. It'll just look messy and jumbled.

Choose your main color based on your audience and the mood you want to convey to them. Once you have that, you can use it to decide on your accent colors. Look for a color wheel online, or use Canva's color wheel, for help. If you are only using one accent color, you can go bold by choosing the color opposite your main color (its complementary color) on the color wheel. An example of this would be yellow-green (chartreuse) and lavender. If it sounds odd, think of a beautiful lilac tree, and you'll see how well it works. If you are using two or more accent colors, you can keep it elegant by using analogous colors, those that are next to each other on the color wheel. These can create harmonious, eye-pleasing designs. Another option, if you are using three colors, is to go with a triadic color design. This would use three colors that are equidistant to one another on the color

wheel. It will create visual contrast and balance at the same time, resulting in a bright, dynamic image.

BONUS TIP 2: DESIGN TIP 2: TYPOGRAPHY

Typography is the art of combining fonts - not just the font family, but also other attributes such as font size, bold, and italics. When you are creating designs, it's easy to get caught up in how it looks. But for design to be effective, one of the most important factors is readability. If your audience can't read your message, how will they be able to respond to it? So make sure that your message is easy to read.

You never want to over do it with typography. Two different fonts, or maybe three at the maximum, is more than enough, especially for smaller pieces. If you keep adding new fonts, the design will look disorganized and not be easy to read. For variety, mix up the boldness or font size within the same family, not by adding new font families.

Remember that in design, as in life, less is more.

"Perfection is achieved, not when there is nothing more to add, but when there is nothing left to take away."

Antoine de Saint-Exupery

RESOURCES FOR GRAPHIC DESIGNERS:

https://blog.creatopy.com/graphic-design-tips/

https://www.smashingmagazine.com/2010/01/color-theory-for-designers-part-1-the-meaning-of-color/

https://99designs.com/blog/tips/typography-design/

https://www.color-meanings.com/

READ OTHER
50 THINGS TO KNOW
BOOKS

50 Things to Know About Coping With Stress: By A Mental Health Specialist by Kimberly L. Brownridge

50 Things to Know About Being a Zookeeper: Life of a Zookeeper by Stephanie Fowlie

50 Things to Know About Becoming a Doctor: The Journey from Medical School of the Medical Profession by Tong Liu MD

50 Things to Know About Knitting: Knit, Purl, Tricks & Shortcuts by Christina Fanelli

50 Things to Know

Stay up to date with new releases on Amazon:

https://amzn.to/2VPNGr7

CZYKPublishing.com

50 Things to Know

We'd love to hear what you think about our content! Please leave your honest review of this book on Amazon and Goodreads. We appreciate your positive and constructive feedback. Thank you.

Printed in Great Britain
by Amazon

73207306R00047